Watercourse

A Poetic Investigation from Source to Sea

Ginger Teppner

Images
Homa Shojaie

For Billy and Farid

Prologue

Languid poet watches, documents, validates, refutes, shares, questions, changes, compiles, and preserves inherent knowledge of what we are capable of bearing and waits for truth to stream past preconceived thought patterns—the purest expression
beyond levels of dramatic narrative
speaking in dialect of indestructibility
born of a thousand damp splinters
refracting points of light, which probe—borderless boundaries—froth between merging bodies of water—film between opacity and translucency—the fluid feminine—
the Watercourse

~permeating~eroding~flooding~nourishing~depositing~quenching~saturating~percolating~cutting~

Source

The point at which something springs into being or from which it is derived or obtained. The point of origin, such as a spring. The point of a system where energy is added.
Rivers begin in mountains or hills where rain water or snowmelt collects and forms tiny streams called gullies. Gullies either grow larger when they collect more water and become streams themselves or meet streams and add to the water already flowing. When one stream meets another and they merge together, the smaller stream is known as a tributary. The two streams meet at a confluence. It takes many tributary streams to form a river. A river grows larger as it collects more tributaries.

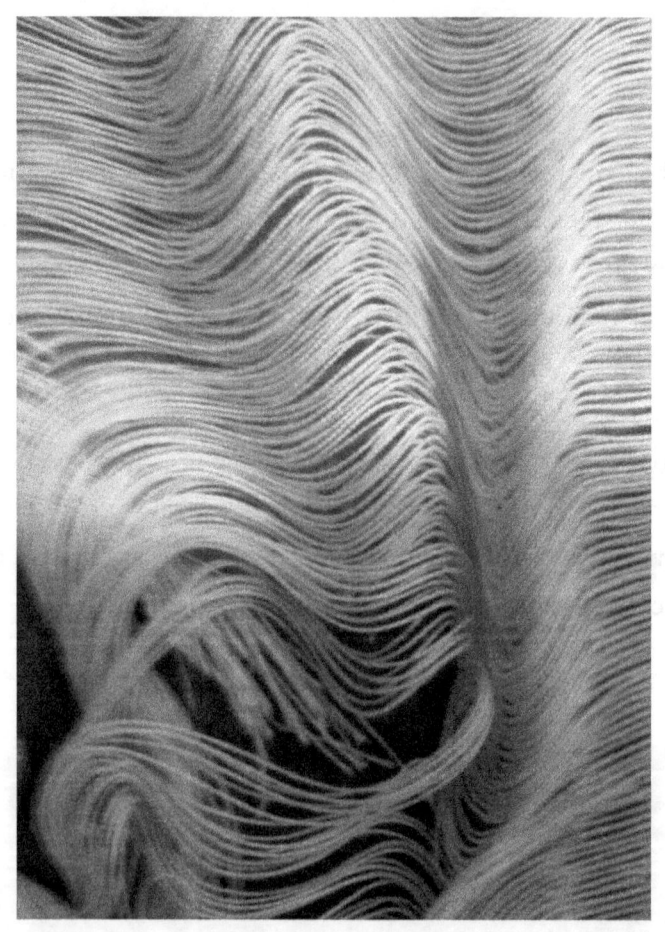

*Between specificity and absolute – a universe
compressed into tiniest mole kissed lash line
a transitional space once secure and stabilized
now loosened like soil whose particle obsession
has lost its glue only to be sucked like poison
sequestered in the amniotic language of liquid*

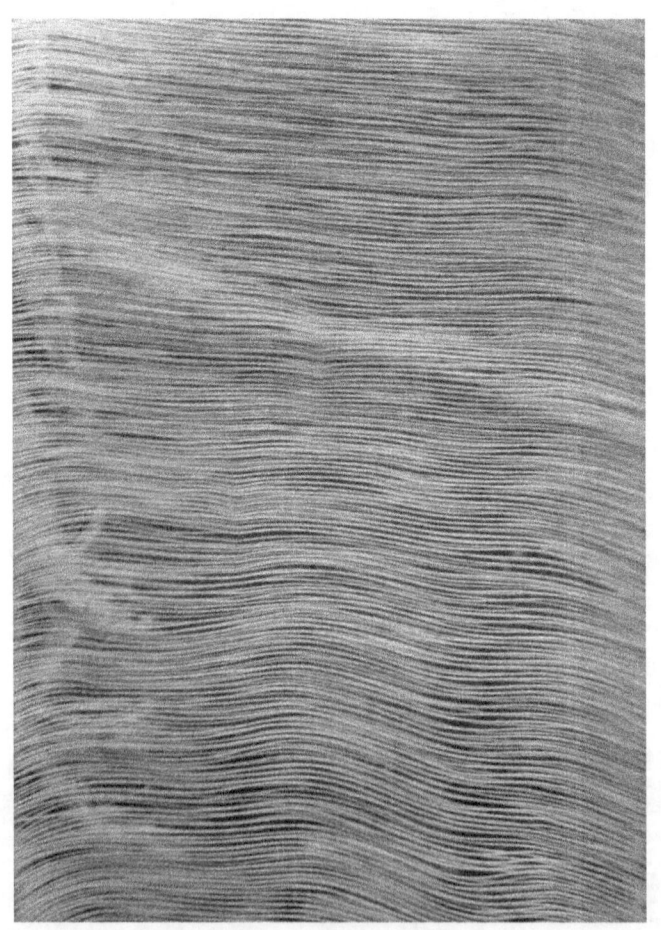

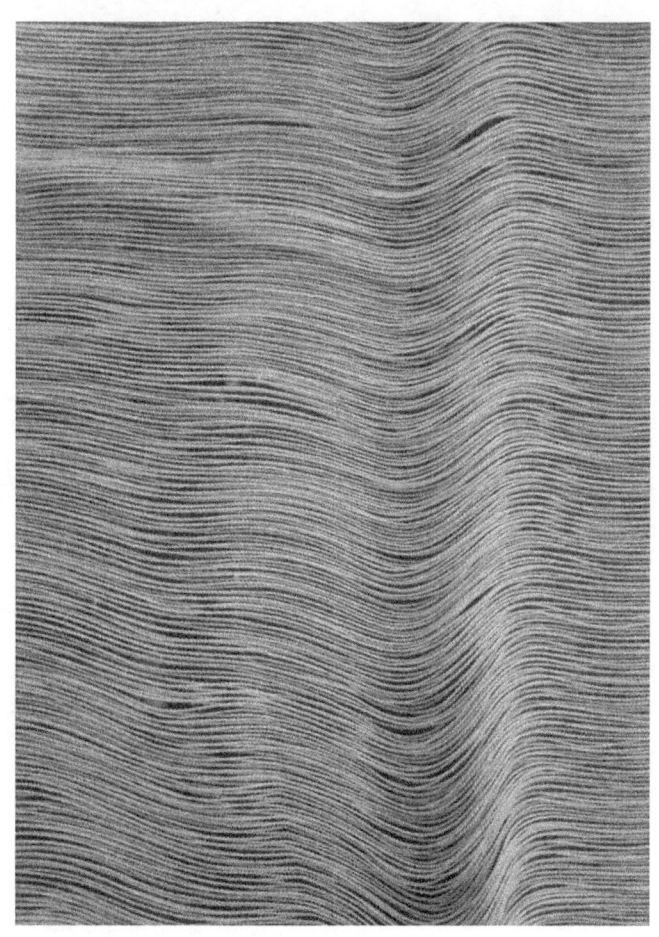

High Course

Movement is rapid in the high course. Water trickles and then descends with increasing force through strong v-shaped valleys. When current flows quickly through narrow shallow channels, erosion is very strong.

A dialogue exists between slit and compression—between compression and combustion. Long standing personal boundaries are permeable at best.

Middle Course

The slope is getting smaller. Water descends more slowly, carrying the eroded materials. Here the river can form meanders while adapting itself to obstacles.

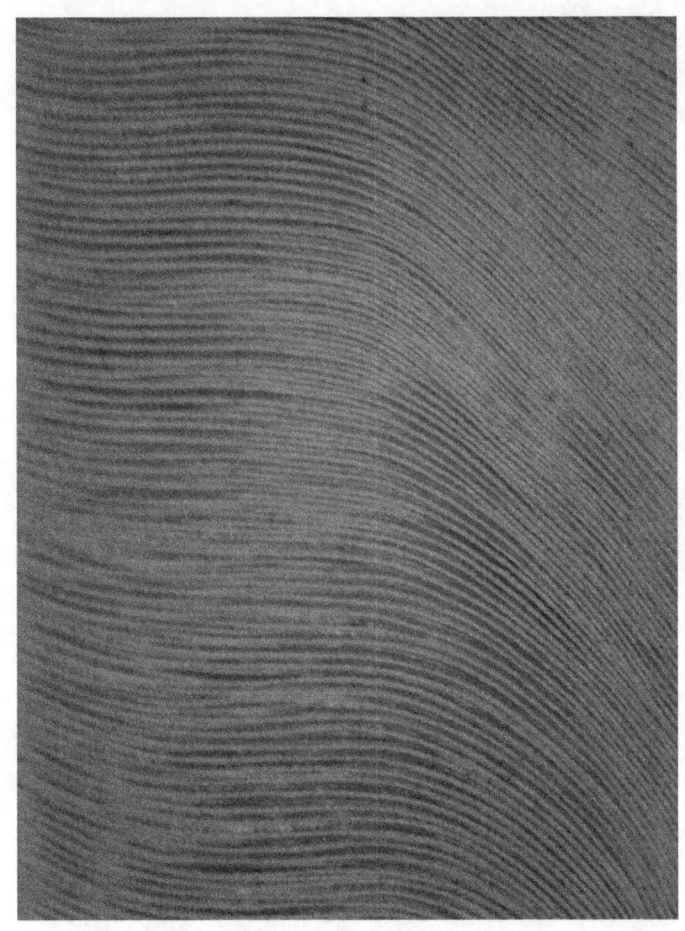

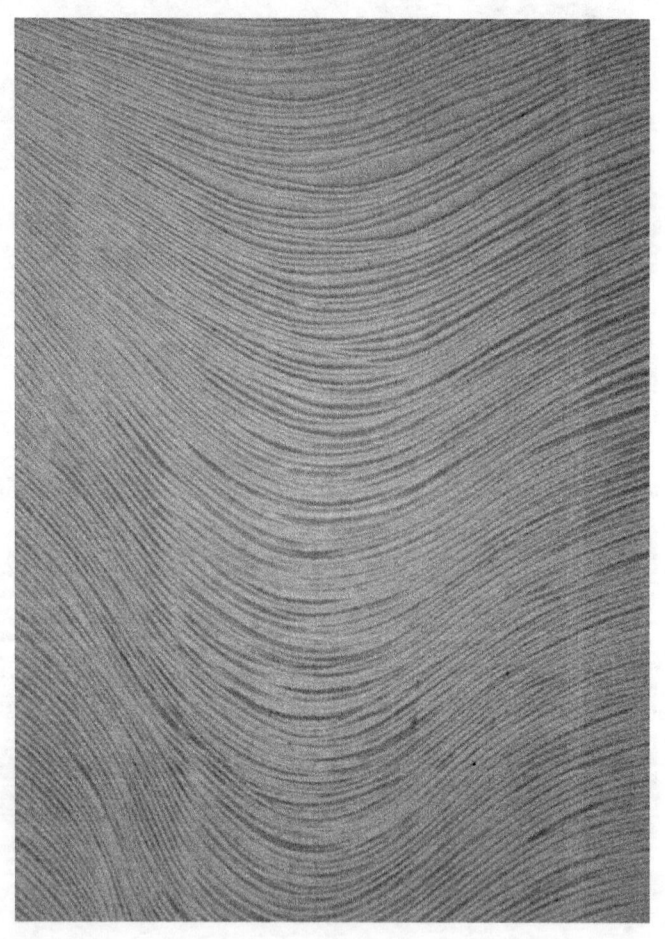

Rushing Seaward

 gaining momentum
 now capable of absorbing
 of salvaging
 all manner of detritus
 from watershed
 boundary's edge
 a slingshot to cast
 away moments
 like skipping stones

 stepping stones stone bruised

 memories
 and snippets

 of down-cast conversation
 the implied horror of words
 irrevocably beautiful
 on the surface
 where reflection rehearses
 and sets the stage
 for discarded tires and tin cans:

 sun bleached snails

 fished on a brighter day

 flush with everything

 in river's recollection

 and starved for swimmers

Within the context of this existent and ancestral language, the curve of water both distorts and magnifies depending on perspective. Here, there is space and time for experimentation.

Low Course

A river does not only flow. It changes everything. It cuts, moves, deposits, carves, and creates a new surface eventually transitioning by sedimenting into sea the materials, which have been dragged along.

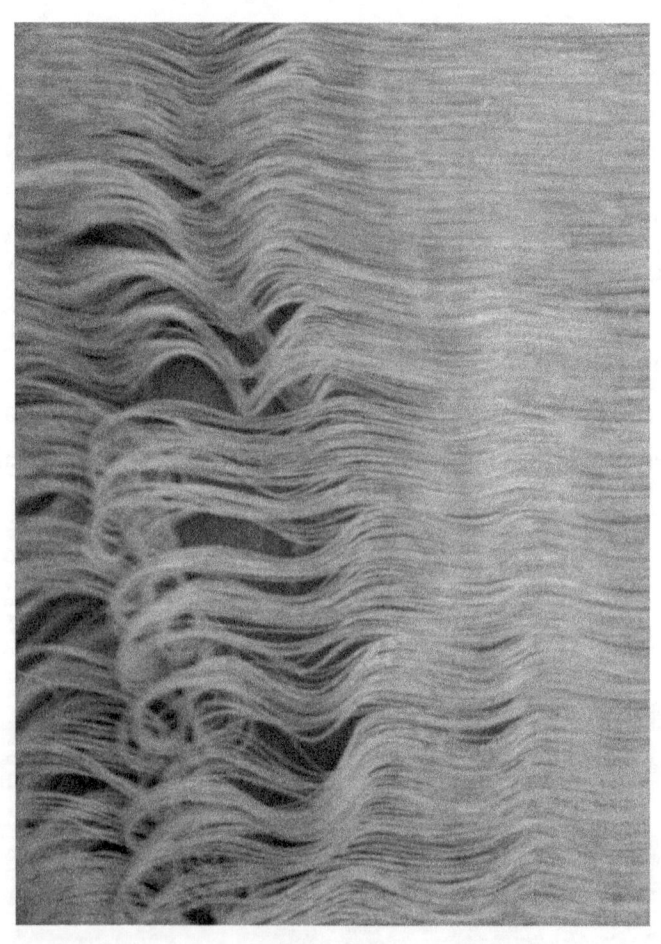

She

 wanted *to swim*

 far out

 where

 no

 woman

 had

 swum *before,*

measure

permeability

 and attest

to union

 whether

 gently *or*

 w I t h

 c a l l o u s-

 n es s

 f I *r* *s* *t*

 b *r* *u* *t* *a*

l

 e *l* *e* *m* *e* *n* *t*

 f r *e* *s* *h* *t I*

d *a* *l*

 o *r* *g* *I* *n*

 i

Estuaries and Mangrove Swamps

Where a river meets the sea there is an ecological succession from a freshwater to a marine ecosystem. Brackish water is water with a level of salinity between fresh water and sea water. The estuary bridges oceans and rivers, and mangrove swamps offer a transitional area of saltiness that ebbs and flows with the tide.

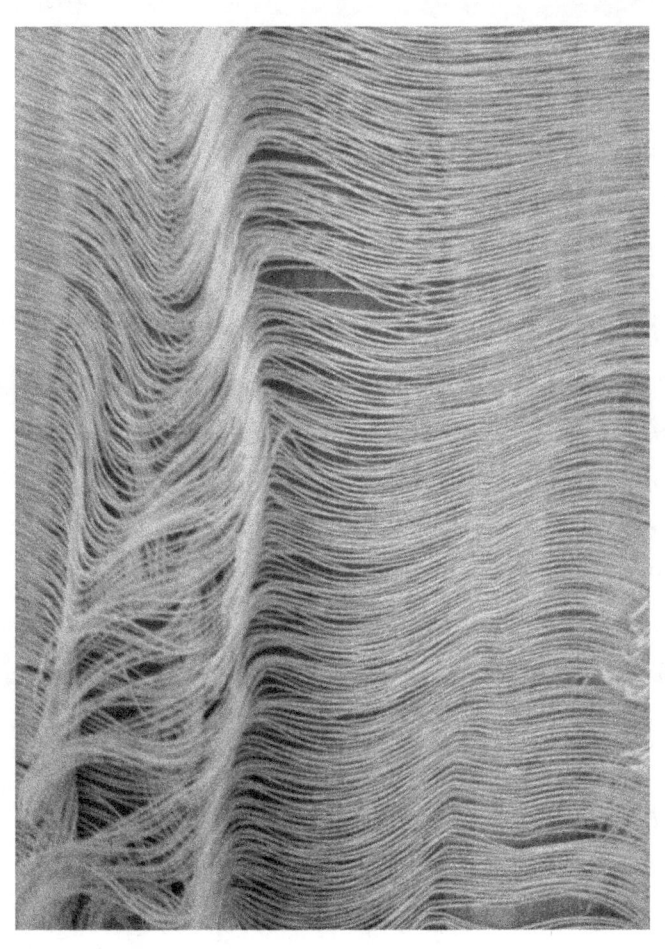

fresh water~brackish water~sea water

Within the transitory space between connection and separation exist nucleotides, the sequence of which comprises the prophetic marriage. Caught within this vault of water between waters—possibility of bridging the cataclysmic rift as measured against sacred husband and profane wife.
To expand the energy heart one must first visit the brackish waters found in estuaries or fossil aquifers. Here exist a range of potential salinity regimes which can vary considerably over space and/or time. Flowing within the mixture of salt and fresh water is the origin of marriage: an idea profoundly imagined by gulls and ospreys that fly, silent witness to repeated thrust of river's sediment into ocean's supple vessel. To expand the energy heart one must first understand this intrusion is welcome, but despite invitation an element of violence inhabits this boundary. To enter is to force, whether gently or with brutal callousness; consequently, integration is tarnished by physiology. All union is suspect in the tidal inlet of the matrimonial sea as outgoing tide falls away.

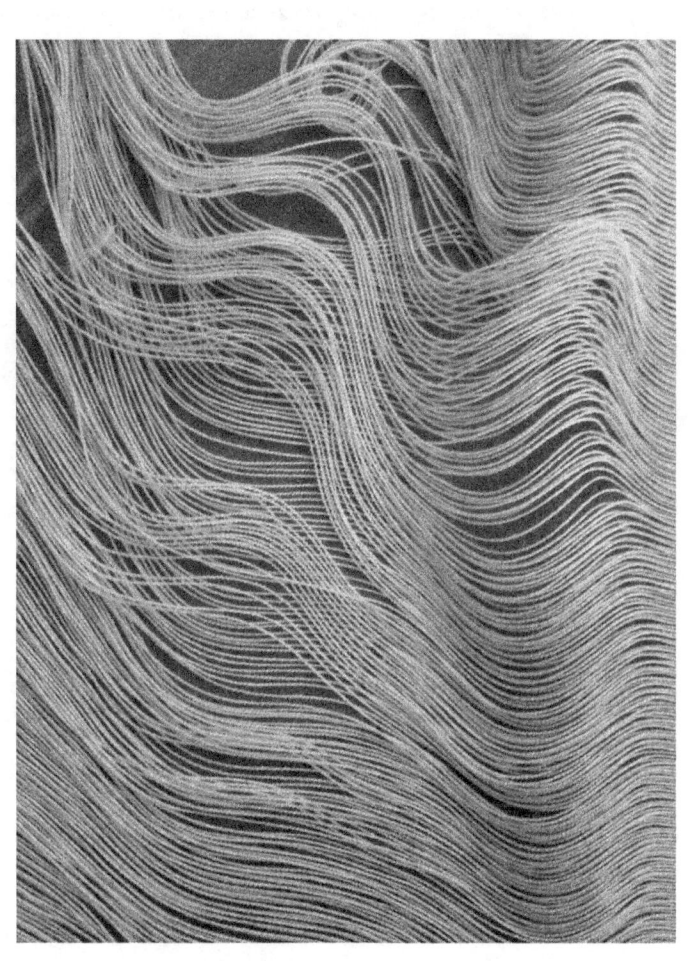

~filtering~evaporating~transporting~mixing~expanding~contracting~seeping~leaking~

Sea

1. The continuous body of salt water covering most of the earth's surface, especially this body regarded as a geophysical entity distinct from earth and sky.
2.
a. A tract of water within an ocean.
b. A relatively large body of salt water completely or partially enclosed by land.
c. A relatively large landlocked body of freshwater.
3.
a. The condition of the ocean's surface with regard to its course, flow, swell, or turbulence: a rising sea; choppy seas.
b. A wave or swell, especially a large one: a 40-foot sea that broke over the stern.
4. Something that suggests the ocean in its overwhelming sweep or vastness: a sea of controversy.
5. Seafaring as a way of life.
6. *Astronomy* A lunar mare.
Idiom:
at sea
1. On the sea, especially on a sea voyage.
2. In a state of confusion or perplexity: at a loss.

(Coda)

Rift-geneous and volcanic
Image presently unmarred
Superimposed reality filtered
Declared and solemnly
Hybrid

Animation fractured
Fractionalized
In anticipation of
Preconditions and desire
For narrative space

Under intense influence
Deep-seated limits
Bind to all that surrounds
To all I connect with
In proximity

Deep within absence
Various parameters
Uniform ocean crust
Beyond all that lies:
Spreading petals

And tenderness?
In alignment
Merging earthly
Temporality
Evolved to present

The morphostructural division
Will help to gain clarity
Not intentional brutality
Only inherent
Oceanic margins

Of present day rifts
Conjugate with young
And in full conformity
With the principle:
No separation

Between points of intimacy
And the point of invasion
There exists no line
Of demarcation
No point from a to b

No line in the sand
No party line
No c-section
Scars zippered together
No laugh line

No stretch marks
No message
No untold story
No intricate webs
Affecting each other

The differing perspectives
Within own mind
Must build bridges
Within duality
Must build bridges

From the periphery
Evolution of ocean
A direct result of entering
The intimate
Disbelief

Entering
Invading intimacy
Intimate invasion
As climate
Caught in the zone

Capacity to endure
As quantified by symbiosis
Between head and heart
Must build bridges
Do you hear me Selkie husband?

Do you hear me Selkie wife?
Mantra encased in glass waves
Mid ocean ridges
And peripheral ocean areas
Rich and depleted

A mirror of one another
As love as ocean
As overwhelming sweep
Vast without requirements
An indestructible bridge

Unlimited, eternal, and free
Fluid linguistic atlas of life
Its own inner source
Earthly body dissolved
Into relief parameters

Spreading centers
Crying out for change
Curtains of molecules
Ripped to shreds
Reminiscent

Borderless borders:
Outward existence conforms
Inward life questions
A space waiting for
Rather than rushing into

Energy of carelessness
The external assumption
Roles, identity, and authority
Governance and tendency
Point to clear interrelation

This is not an easy task
However, the soul knows
What the soul knows:
Continuity
Is just another word

When things do not fit
This mental image
In any lineage
Maybe we have only
Then touched truth

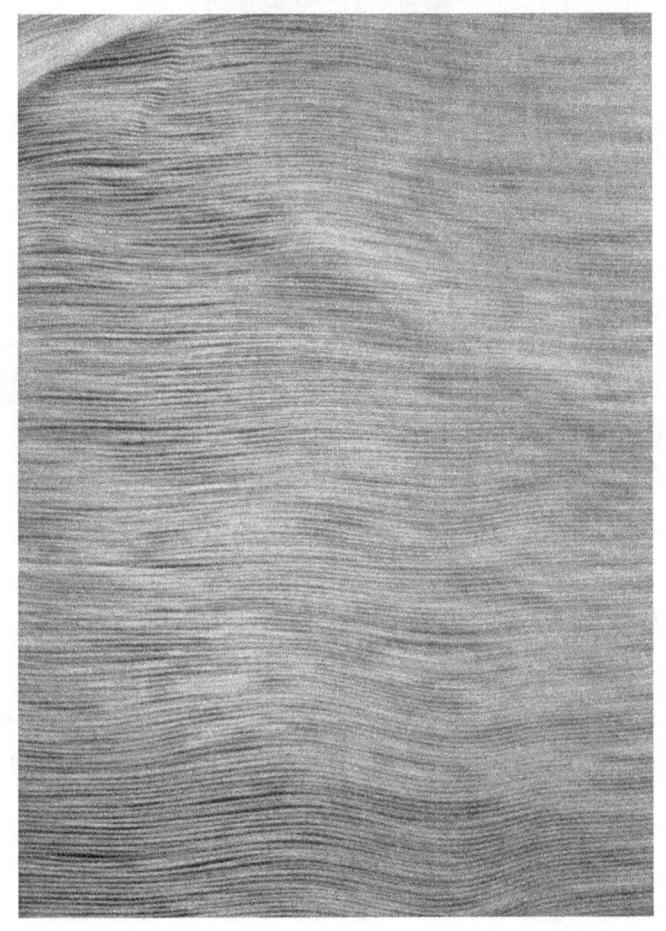

About the Author

Ginger Teppner received her MFA in Creative Writing from the Jack Kerouac School of Disembodied Poetics at Naropa University and her BA in Cultural Studies from Empire State College. Her work has appeared in Bombay Gin, Erasure, Semicolon, Upstairs at Duroc, Phylogeny, Shambhala Times, Not Enough Night, Metropolitan, Yew Journal, and more. Her chapbook *28 Gestures* appears in the anthology *Precipice,* and her chapbook *I Should Have Been Linen* was chosen to be included in the summer 2017 issue of *The Lune.* Her most recent endeavor, facilitating an online workshop of artists for Arts Letters & Numbers, culminated in a book: *The Earth Of: writing through a time of rupture,* which is composed of participants' work that spans a broad range of disciplines. She is currently teaching English at Ridge Community High School as well as adjuncting and continuing to lead writing workshops. Her written work investigates the collapse of subject/object dichotomy, the democratization of language, and the transcendental nature and essence of words while juxtaposing the exotic with the prosaic. She is interested in fragments that make up experience, how memory is selective, trees, birds, rivers, and bridges.

About the Artist

Born in Iran, Homa Shojaie's work is concerned with space and image and their intersection with materiality and perception. She received a Bachelor of Architecture from The Cooper Union and a MA in Fine Arts from LaSalle College of the Arts. She has taught at Pratt Institute, Illinois Institute of Technology, School of the Art Institute of Chicago, LaSalle College of the Arts, and has been a visiting Artist at Arts Letters and Numbers. She has exhibited in Chicago, New York, Detroit, Izmir, Kashan, and Singapore.

www.ingramcontent.com/pod-product-compliance
Lightning Source LLC
Chambersburg PA
CBHW071445170526
45158CB00005BA/1839